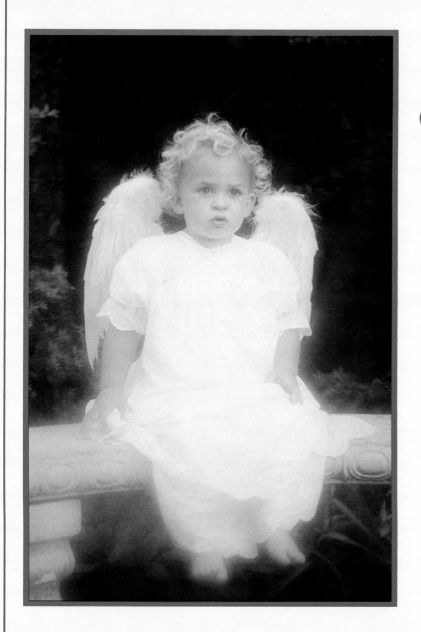

Angels
From
the Heart

by
Ho Phi Le

Published by Hobby House Press, Inc.
Grantsville, MD 21536

This book is lovingly dedicated to:
Angela, my godchild
Willie, my littlest angel
&

In memory of Jessica, Kristin
& my brothers; Hoai Huong & Phi Phuong

Additional copies of this book may be purchased at $14.95 (plus postage and handling) from
HOBBY HOUSE PRESS, INC.
1 Corporate Drive
Grantsville, Maryland 21536
1-800-554-1447
or from your favorite bookstore or dealer.

© 1995 Ho Phi Le

Printed in the United States of America
ISBN: 0-87588-431-8

From the Heart

Do you believe in angels,
the spiritual beings superior to humans
in power and intelligence?
Do you believe that there is a gentle spirit
who guides you to the aspect of love and truth?
I do.
I believe in the gentle soul
who whispers softly to my heart
the true meaning of love
and who guides me
to do the right things for my soul and for others.
To express my feelings
for the angels of my childhood,
I have the privilege of capturing their images through the
visions of our talented artists of yesteryear and today.
I truly hope these images will capture your heart with love
and let you get in touch with your deepest feelings
once again.

Ho Phi Le

Show Me The Way

Show me the way to find true happiness,
for there is so much sadness in this world.
Lead me to do the right things
for those who are in need of saving their lost souls.
Help me share my compassion with those whose pain is
so great that their hearts are no longer able to accept
the greatness of our beloved God.
Let me touch their lives in such a way that they can begin
a new journey in the name of our Lord.

Ho Phi Le

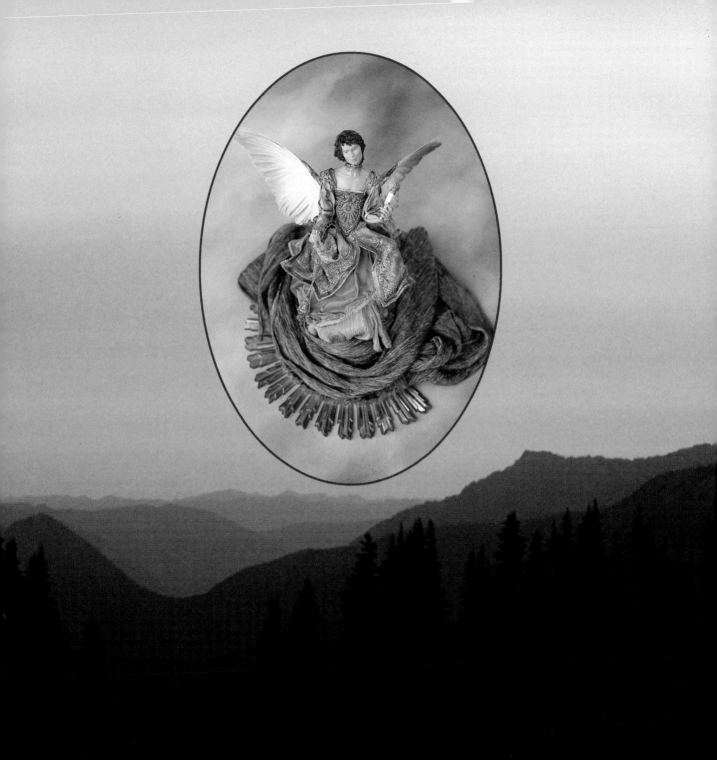

For every soul, there is a guardian watching it.

The Koran

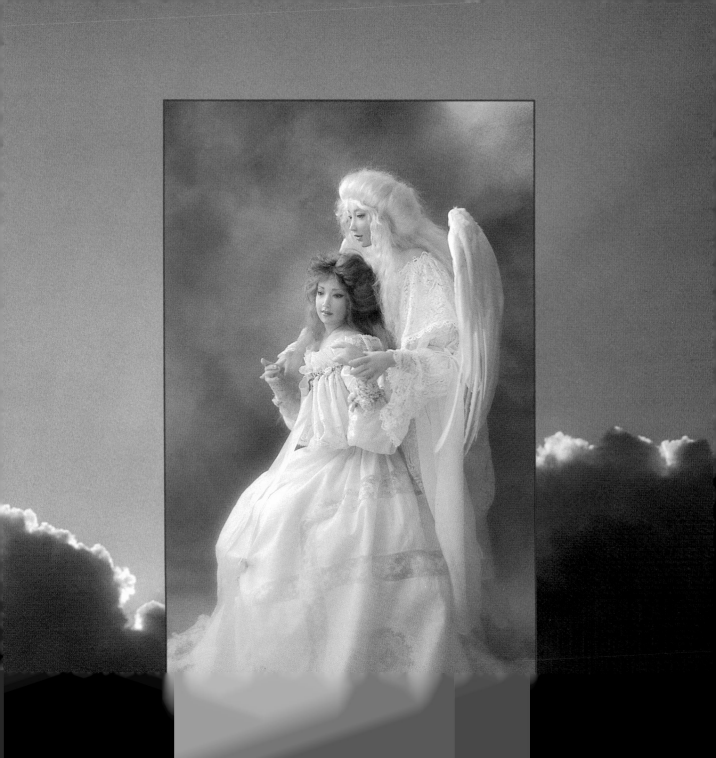

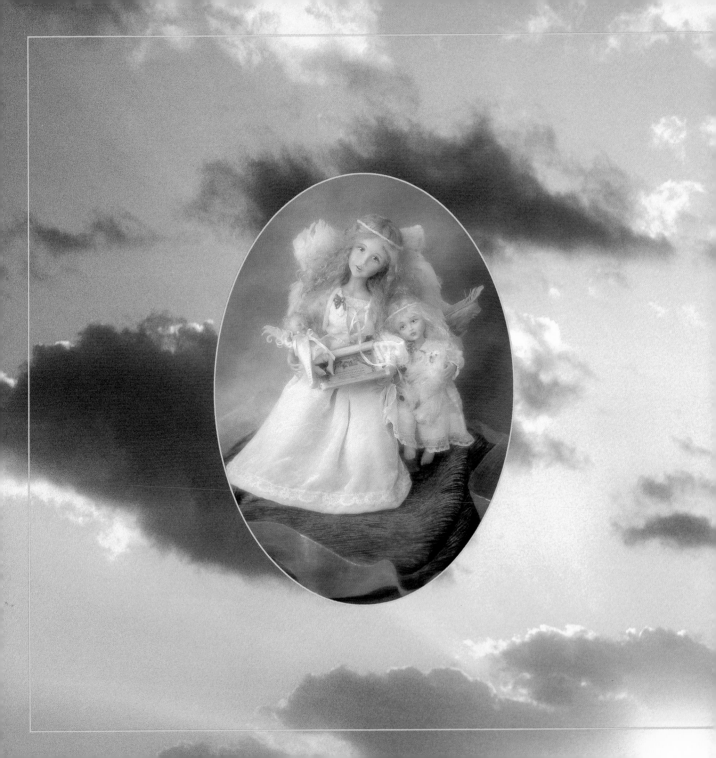

When I think of angels,
I think of my mother.
I believe that she is only one step away from that state.

Linda Kertzman

*Everything I feel about angels is in their eyes.
They know and understand
our most inner thoughts, feelings, and needs.
Their guidance and help come to us in ways
we are sometimes unaware of.*

Rosemary Volpi

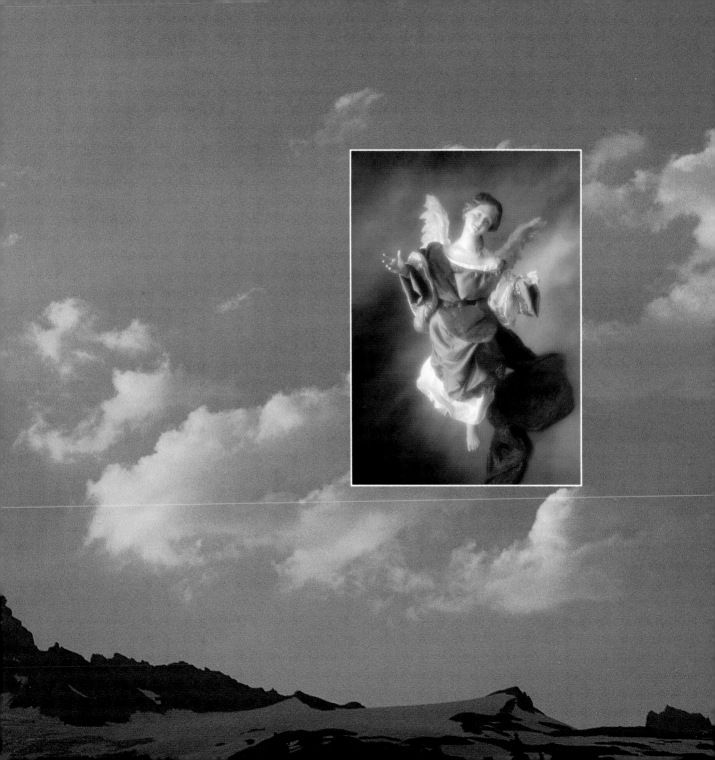

To me Angels represent...
Love, Purity, Wisdom, Strength,
Compassion and Peace.

Rosemary Volpi

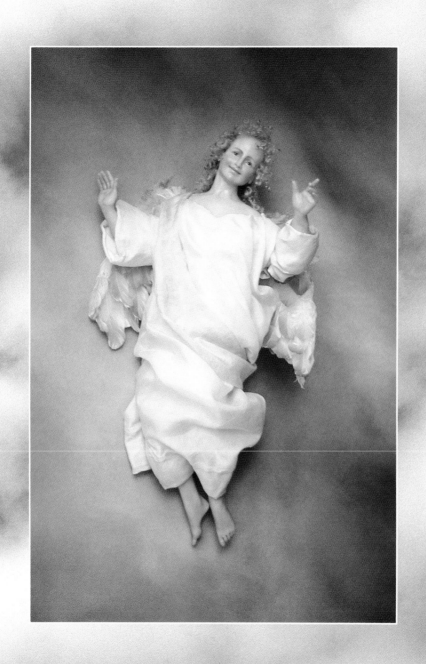

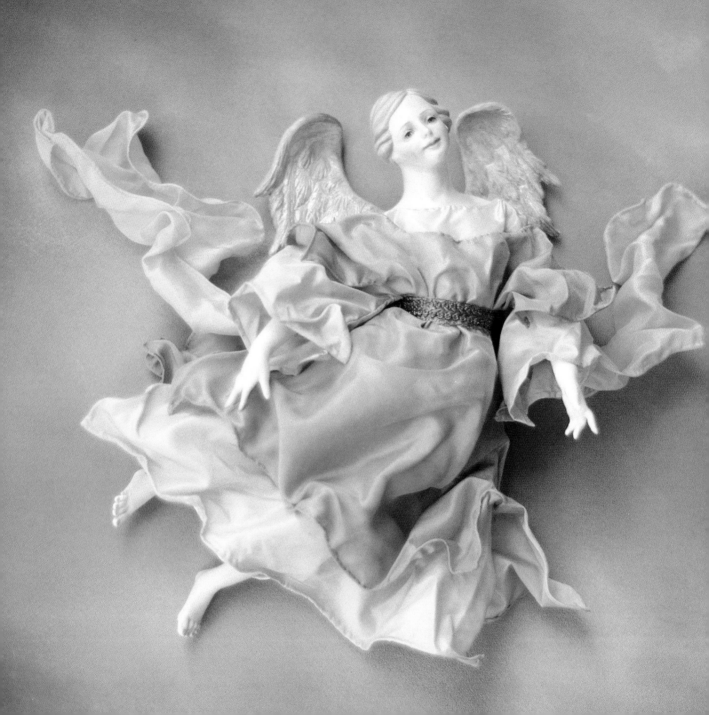

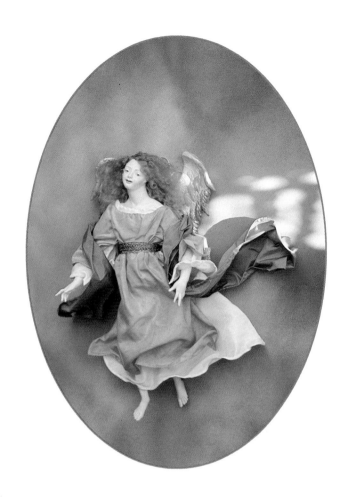

\mathcal{F}or those of us who learned to see
while listening at our Mother's knees
know that Angels fly above
as sure as there is Earthly love.

Susan Dunham

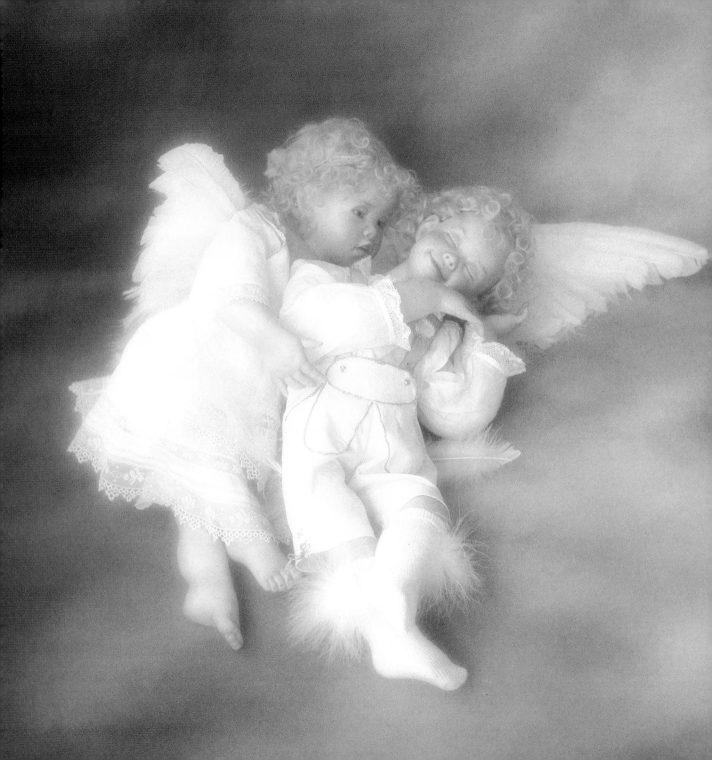

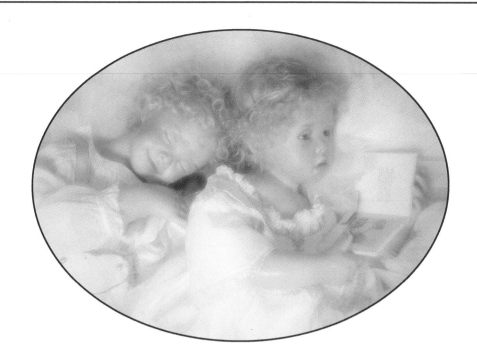

*When I was young,
sometimes I was left to tend
my brother and sister at night.
I used to be very frightened,
so my mom told me
that an angel
folded his wings around our home
to keep us safe.*

Susan Krey

When music begins to play,
Little Angel dances gracefully.
Dance with me once,
Dance with me twice,
Dance till the moon shies away
From the star light, star bright.
Little Angel of my youth
Swiftly fly into the moonlight.

Ho Phi Le

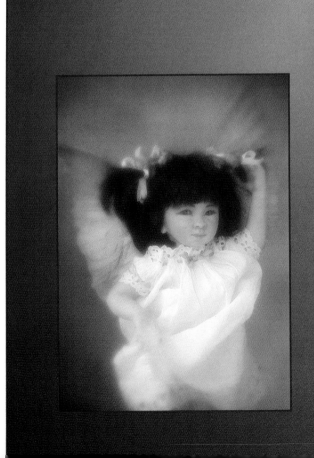

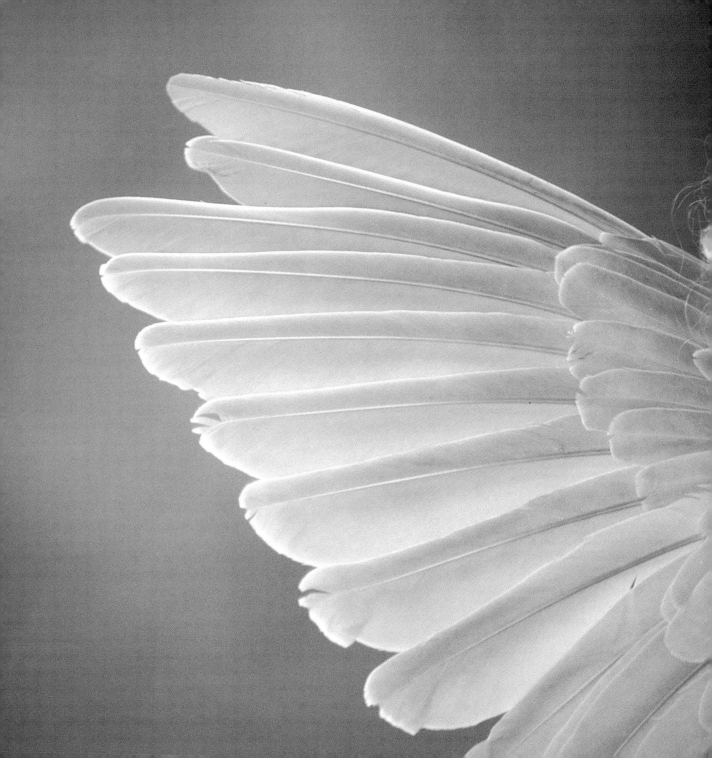

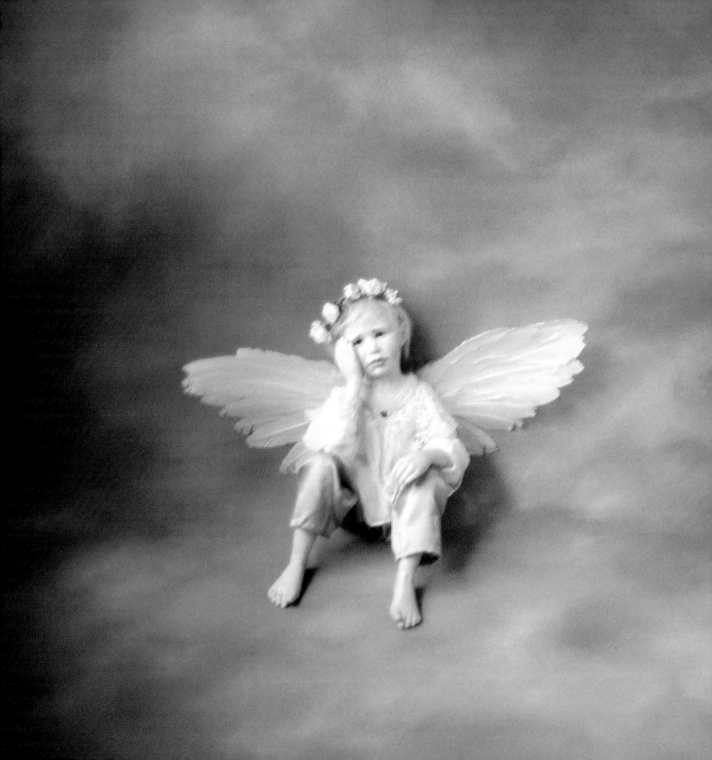

In My Prayer

I feel connected
to the Lord
knowing that there is
an angel
on my shoulder.
I feel loved
by the goodness of God
in my prayer
each hour of my day.

Ho Phi Le

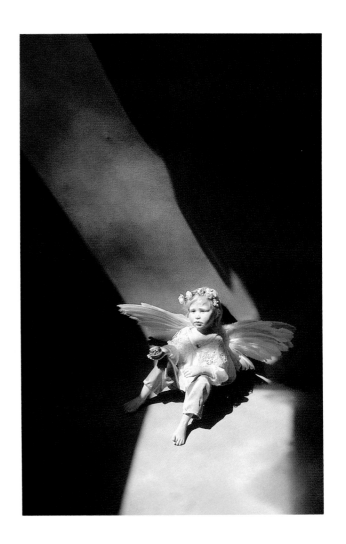

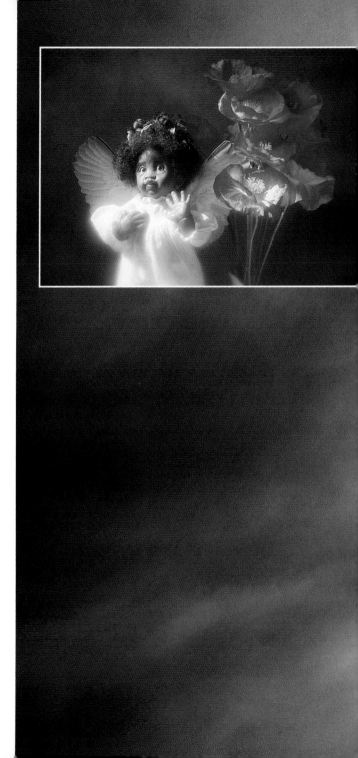

*Although I have never seen
an angel,
I have looked into
the faces of beautiful children
and I am sure
I have looked upon
faces of angels.*

Lleana Davison

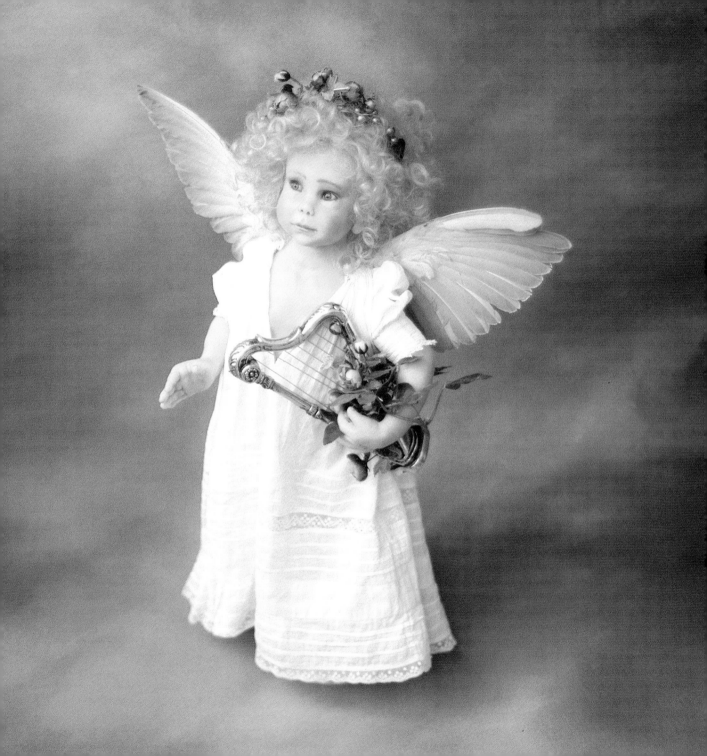

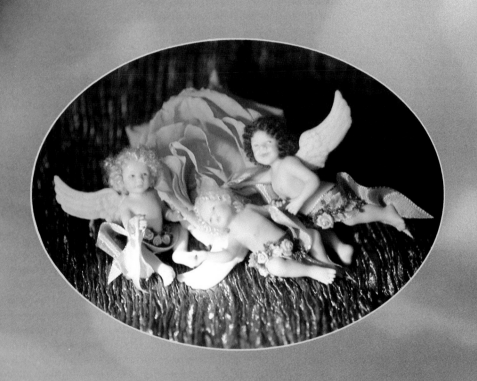

*Baby is an angel
whose wings decrease
as his legs increase.*

French Proverb

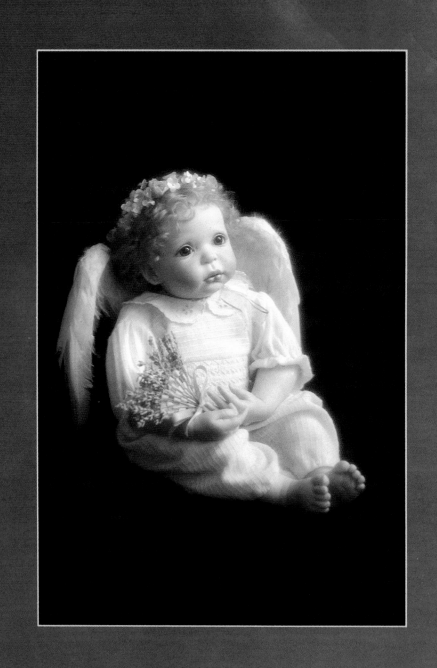

Baby angel is so small,
Baby angel is not tall,
Baby angel has tiny feet,
Baby angel is so sweet.

Gabriel Connant
(8 years old)

Listen carefully to the voices of angels,
and you'll hear whispers
of love and happiness,
Just listen patiently to your heartbeat,
and you'll feel deep in your soul
the presence of angels.

Ho Phi Le

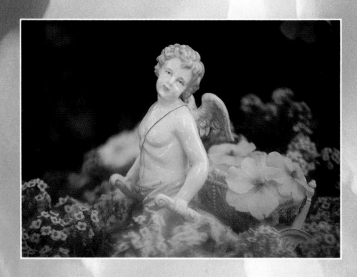

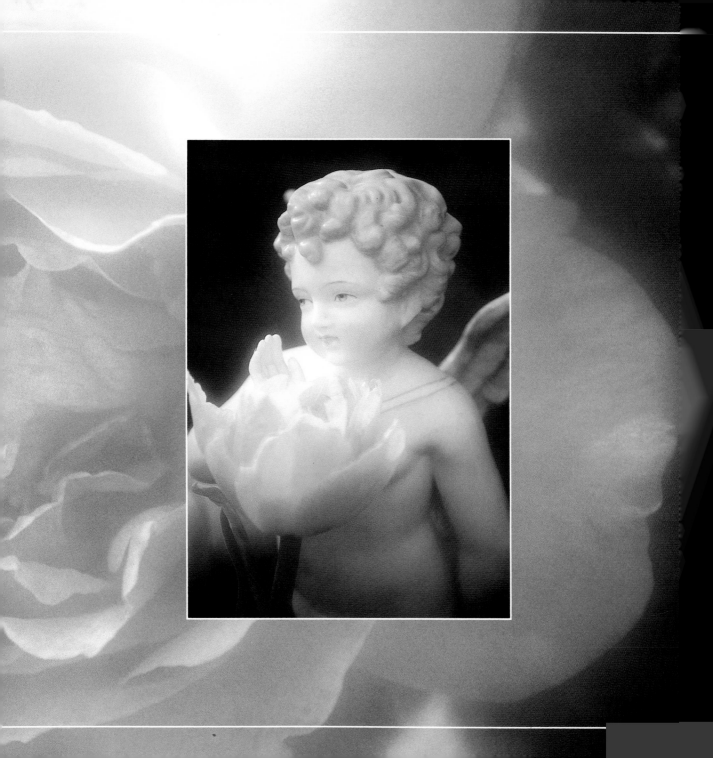

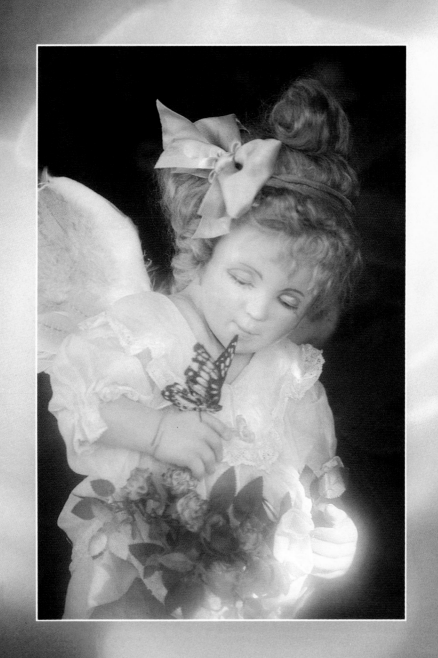

*Every visible thing
in this world
is put in charge of
an angel.*

St. Augustine

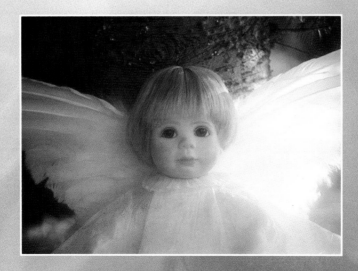

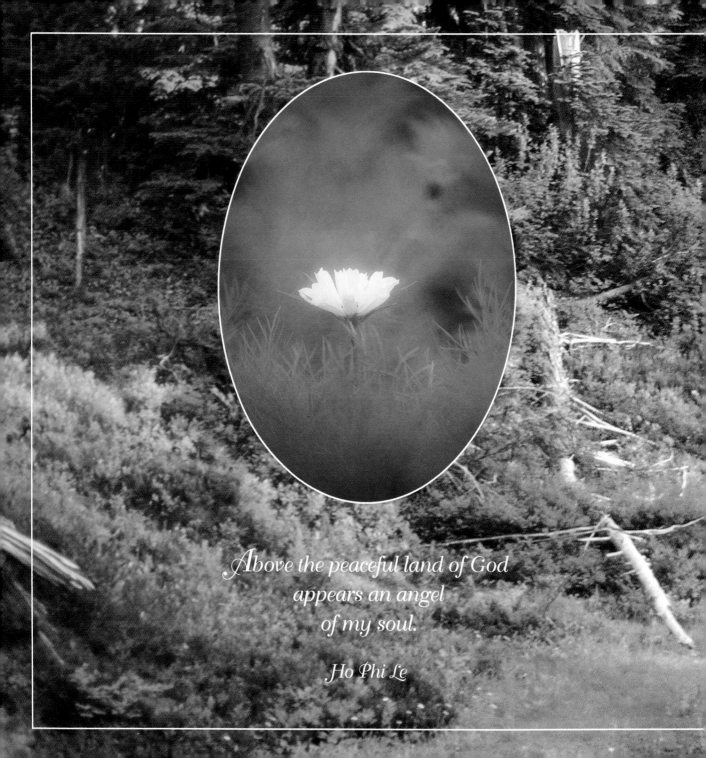

Above the peaceful land of God
appears an angel
of my soul.

Ho Phi Le

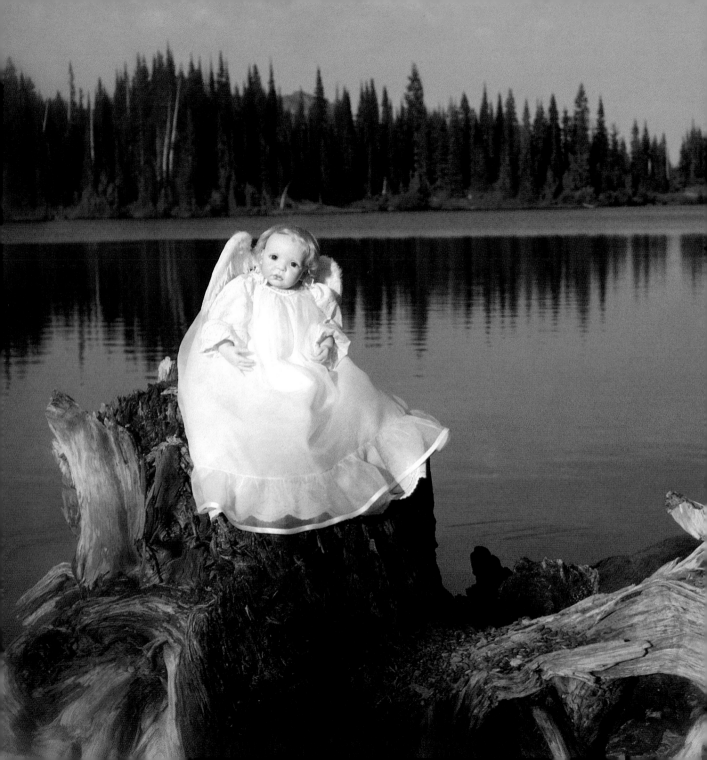

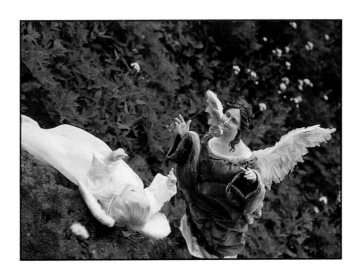

If you believe...
really believe,
Angels of healing
will ease your pain
and heal your sickness,
If you believe,
truly believe.

Ho Phi Le

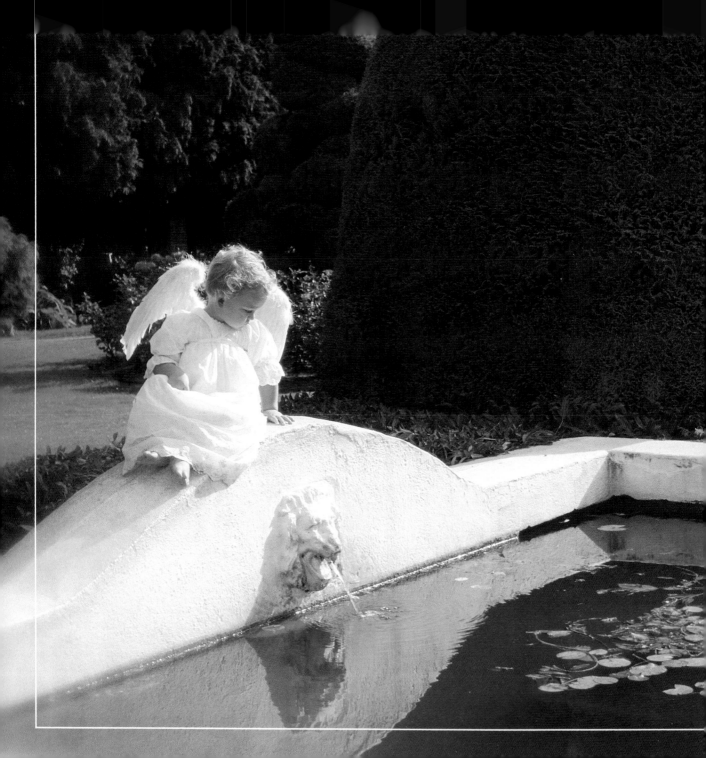

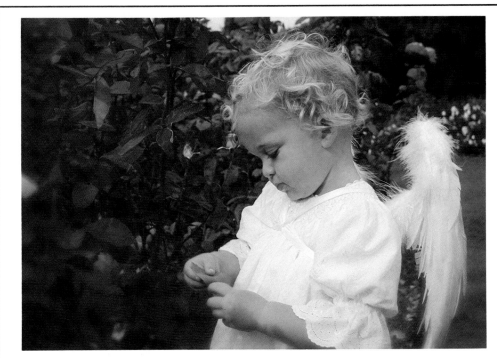

To love for the sake of
being loved is human,
but to love for the
sake of loving is angelic.

Lamartine

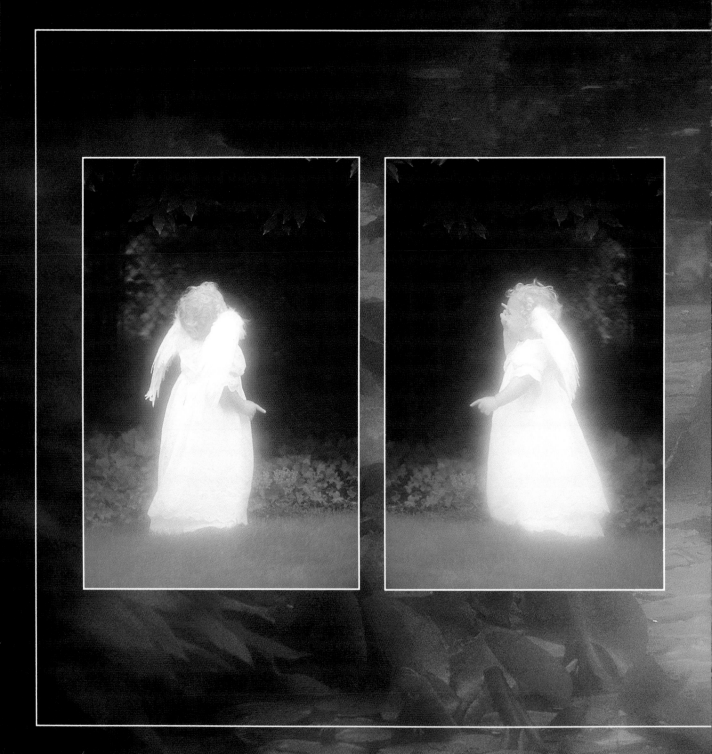

If you look closely into a child's eyes,
you will see an angelic soul
with a heart so pure and fragile.

Ho Phi Le

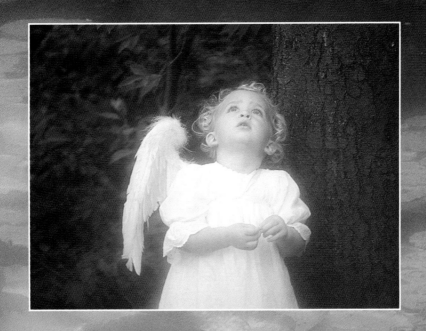

Oh sovereign angel,
Wide-winged stranger above a forgetful earth,
Care for me, care for me.
Keep me unaware of danger
And not regretful
And not forgetful of my innocent birth.

Edna St. Vincent Millay

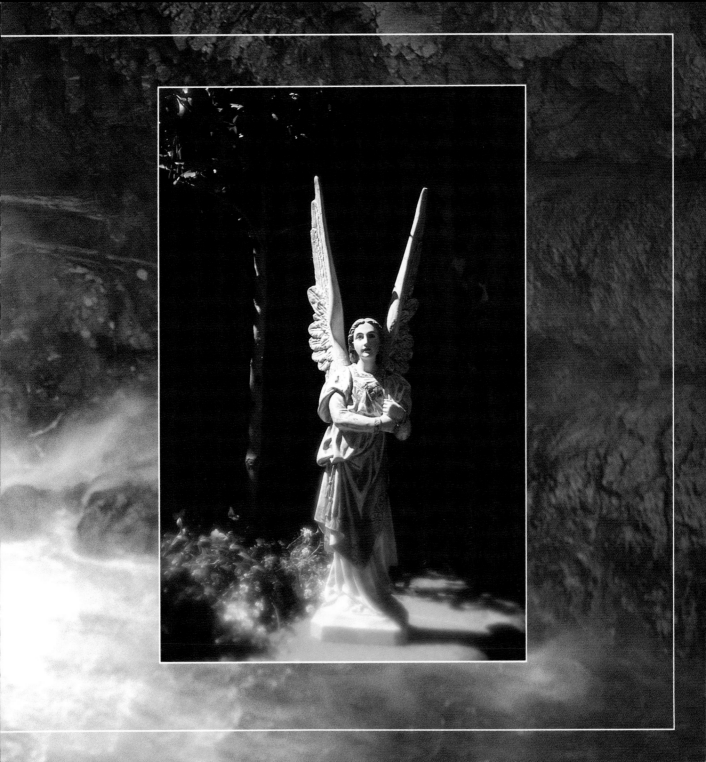

Angelic whispers
The gentlest of guiding touches
Questions asked and answered
By an ever present shadow of light.

Monika

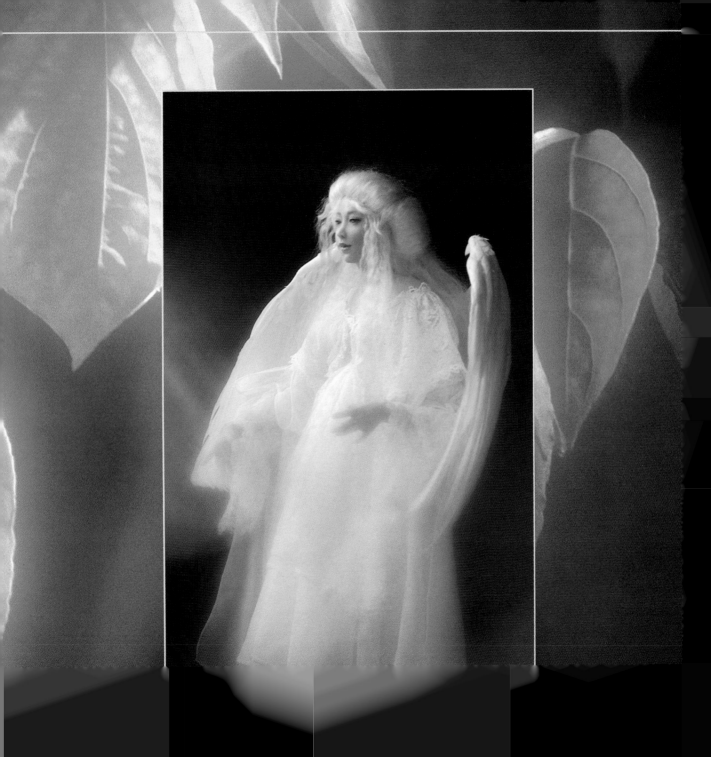

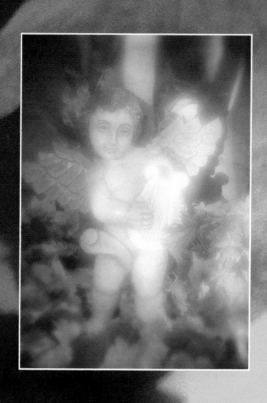

*W*hen autumn comes...

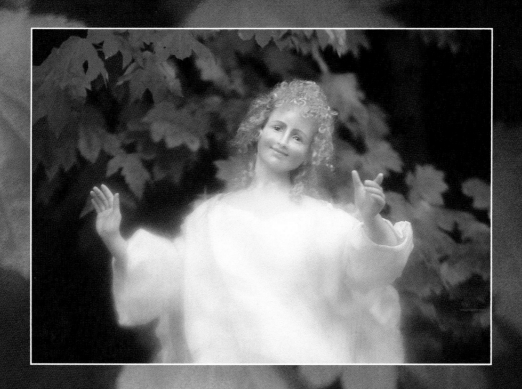

Angels compose the sweetest symphony
for the heart of a human's soul.

Ho Phi Le

Autumn
is the season
of change,
A season
for the soul
to search
within.

Ho Phi Le

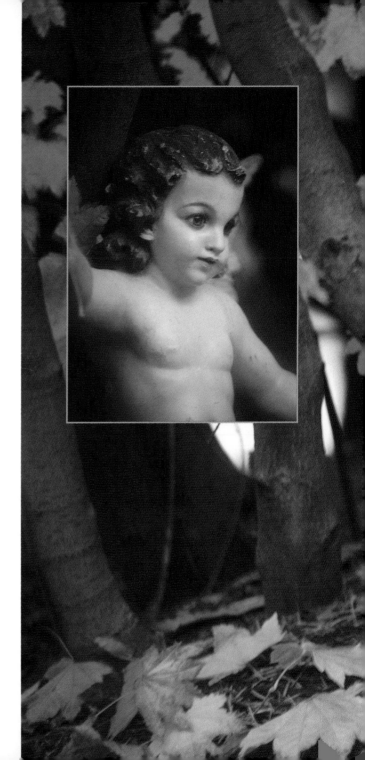

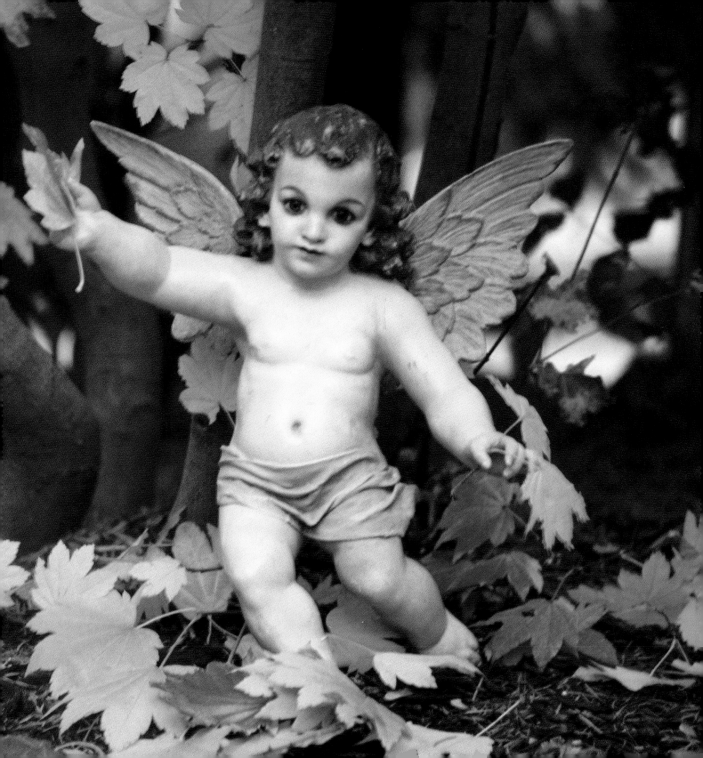

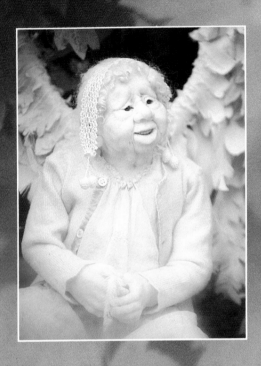

My dear mother had a terrible stroke a year ago.
She was always a very worried, fearful person,
yet during this time
she seemed quite at peace with the situation.
She died peacefully in her sleep last November.
I would like to think that her calmness
was due to the loving effect of her guardian angel.

Beth Cameron

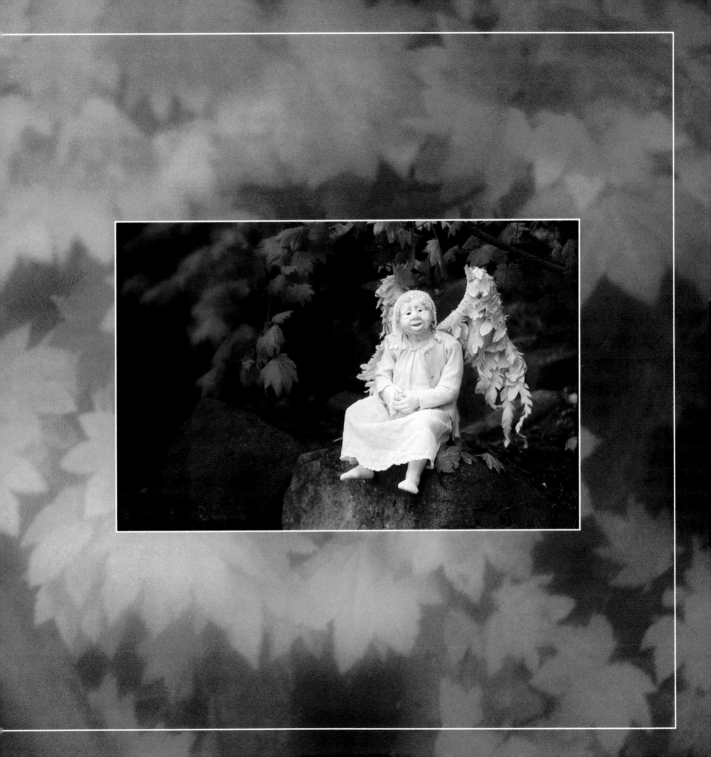

*What sweeter sound
than Angel's strumming.*

Adnan Karabay

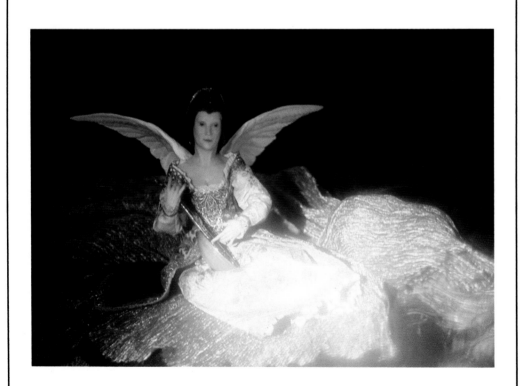

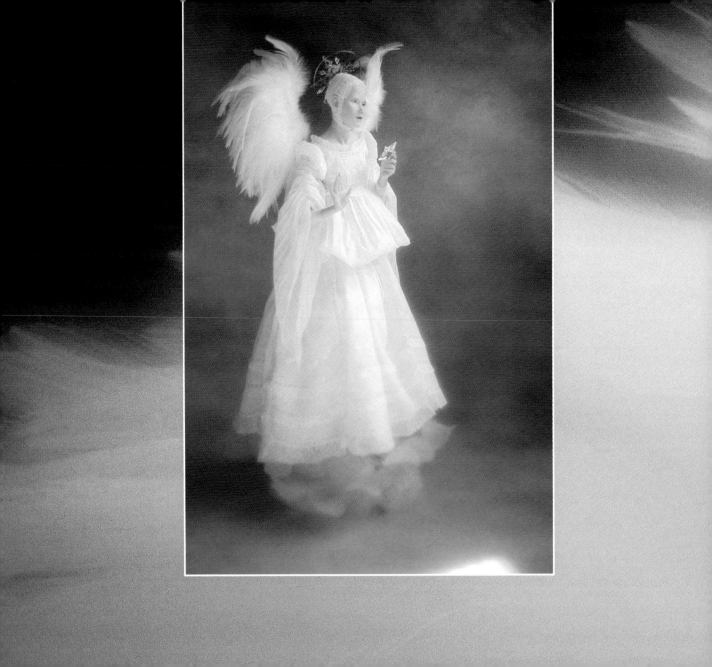

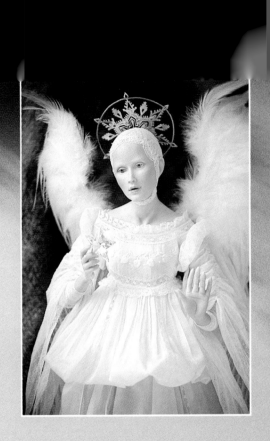

Silently, one by one
in the infinite meadows of heaven
blossomed the lovely stars,
the forget-me-nots
of the angels.

Longfellow

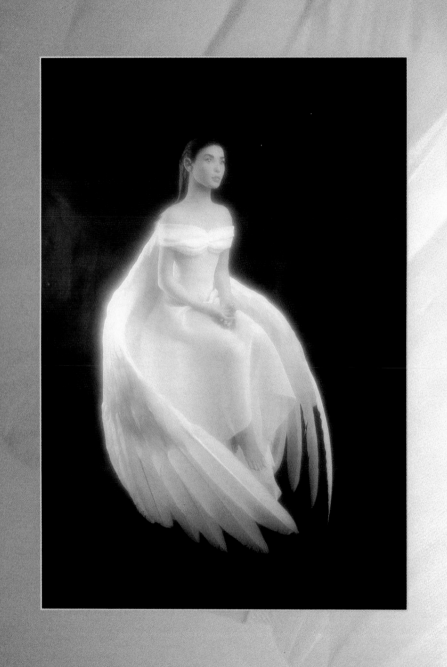

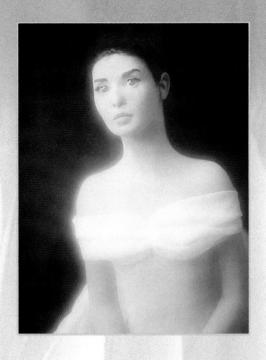

Persephone

*It's time for you to take flight
into a spiritual world
where love is the only reason for being.*

Ho Phi Le

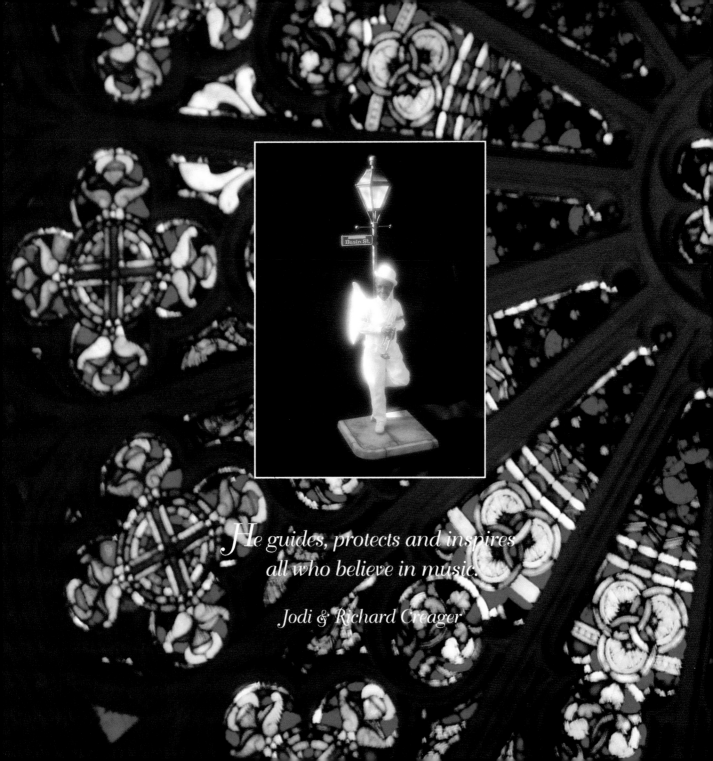

*He guides, protects and inspires
all who believe in music.*

Jodi & Richard Creager

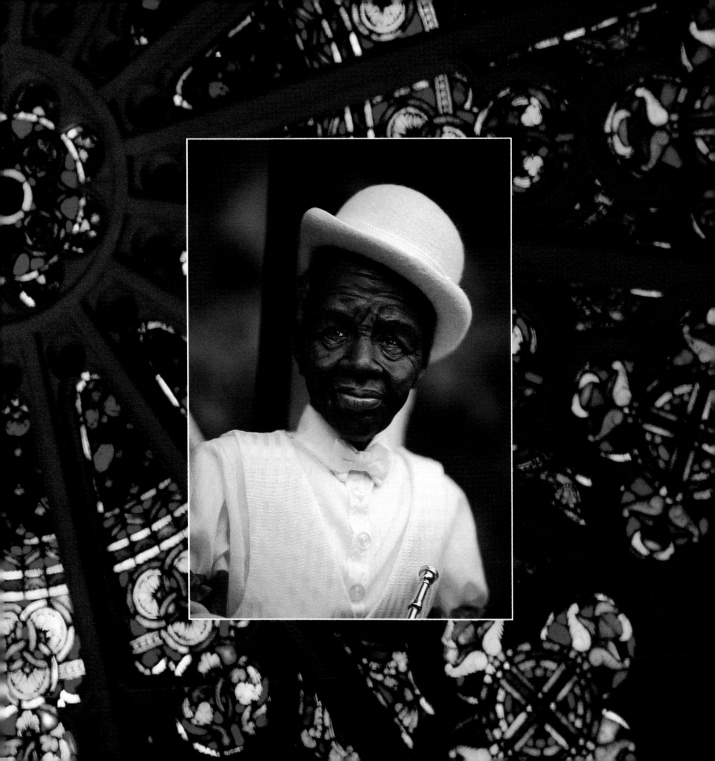

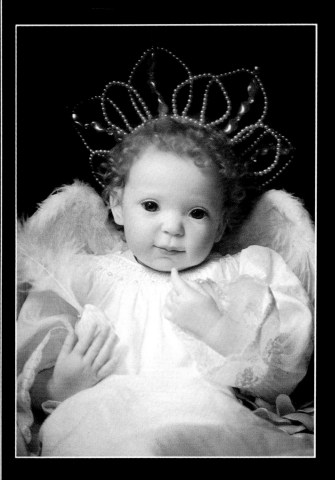
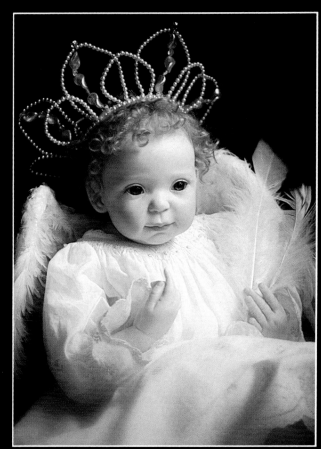

*W*hen babies smile, they are talking to angels.
Their little souls are so pure
that no barriers exist between them and the spiritual world.

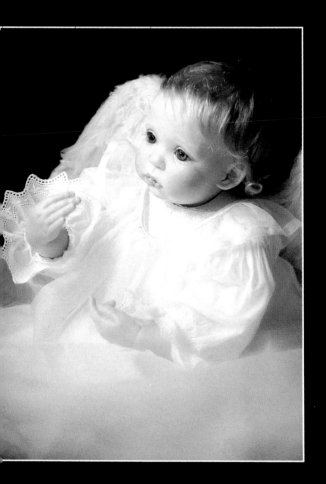
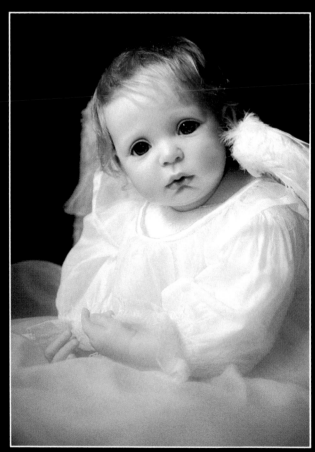

The baby angels can guide us back
to innocence so precious to God.
If we are quiet enough, we'll hear their peals of laughters.

Jeanne Gross

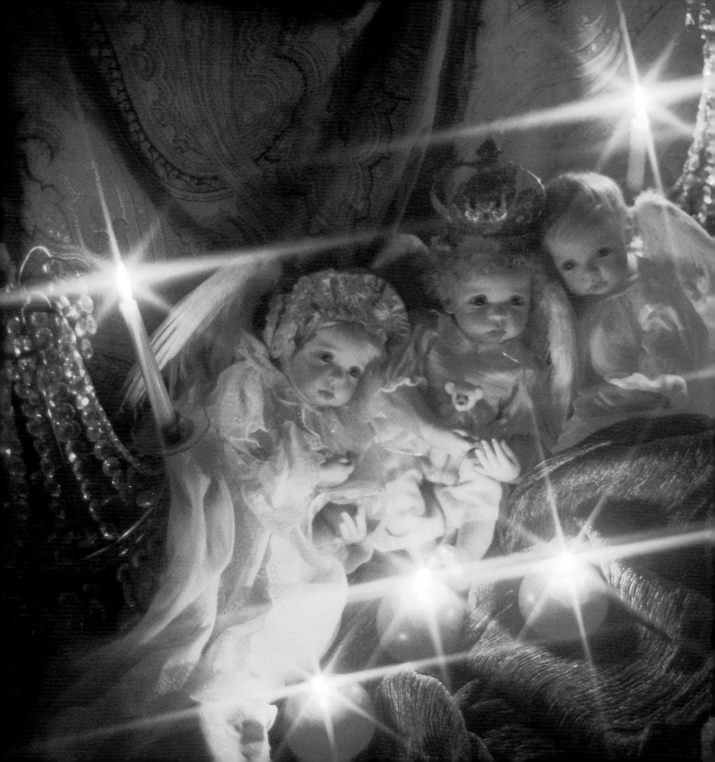

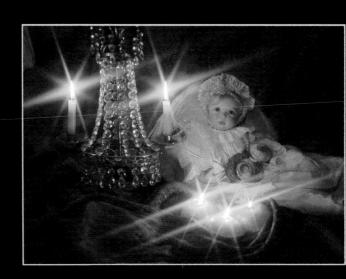

Be there for me,
My angel,
Take care of me,
My beloved,
For the night is
Dark and lonely,
I need you there...
I need to know
That you care.

Ho Phi Le

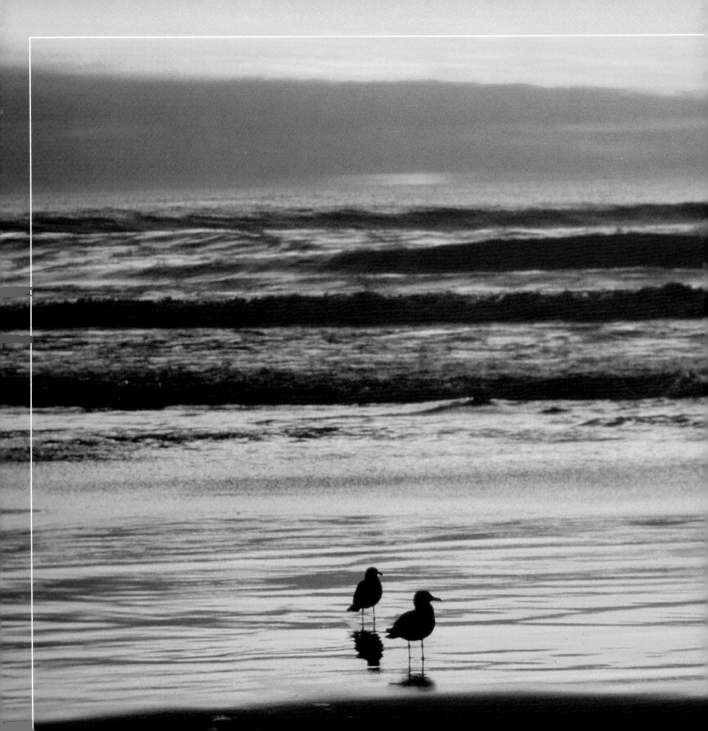

Angel of God
my Guardian Dear
for whom God's love
commits me here,
ever this night
be at my side
to light and guard
and rule and guide.
Amen.

Unknown

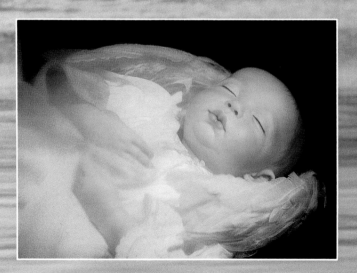

With Love...

To my mother who is my guardian angel...all my life.
Mary & Gary Ruddell for believing in my artistic vision.
Mary Beth Ruddell for being a wonderful editor and friend.
Aimee Ruddell & Margot Skelley for working closely with me on the design of this book.
Carolyn Cook for her true friendship.
Nancy Sandberg for loving me like a son.
Paul Hardin for being my best friend.
Anna Taccino for her generosity in sharing her love with others.
Hazel Coons for being a part of my life.
Rosemary Volpi for sharing her friendship in a gentle way.
Susan Dunham for giving me the angel of her heart.
Dottie Ayers for believing in angels.
Barbara Brandt, Rosie McGrady, Pat Merrill for sharing their thoughts.
Marshall Martin and Jim Fernando for sharing their angels with us.
Hien Luong Do for giving me my beautiful godchild, Angela.
Rosalie Whyel & Susan Hedrick for presenting Angels in Our Midst.
The Brothers of Lasan Taberd in Vietnam who instilled in me the love of Angels and
Saint James Parish for its beauty.
But most of all to our talented artists who have shared with us their heavenly angels,
and for that I am forever grateful.

Dorothy Hoskins pp.52-53; Jodi & Richard Creager pp.56-57; Beth Cameron pp.48-49; Susan Dunham pp.14-15; Rosemary Volpi p.11, 13, 35, 45; Monika p.7, 43 & front cover; Linda Kertzman p.8; Susan Krey pp.16-17; Krisztina Egyed pp.20-21; Adnan Karabay p.5, 50-51; Lisa Lichtenfels pp.54-55; Lleana Davison pp.18-19, 22-23, 30; Jeanne Gross p.26, 34-35, 58-63, back cover; Stephanie Blythe & Susan Snodgrass p.24.

For more information about these artists
or if you want to share your angel stories, please send a #10 SASE to:
Ho Phi Le
c/o Hobby House Press
1 Corporate Drive
Grantsville, Maryland 21536